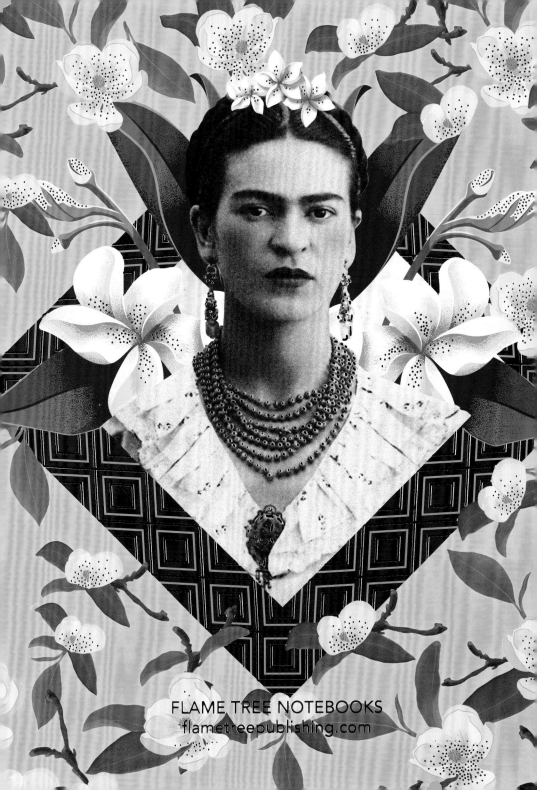

FLAME TREE NOTEBOOKS
flametreepublishing.com

See our range of fine, illustrated books, ebooks, notebooks and art calendars:
www.flametreepublishing.com

This is a **FLAME TREE NOTEBOOK**
Published and © copyright 2023 Flame Tree Publishing Ltd

FTNBL08 • 978-1-80417-683-2

Cover image based on a detail from
Frida Kahlo Botanical Portraits: Yellow
© Frida Kahlo Corporation/Licensed by www.artaskagency.com

One of the most iconic artists of the 20th century, Frida Kahlo's bold, carefully
crafted visual identity is in many respects an extension of her art, celebrating her
Mexican heritage and countercultural ideals while defying traditional notions of female
beauty. Striking and bursting with colour, her portraits resonate as much today as ever.

FLAME TREE PUBLISHING | The Art of Fine Gifts
6 Melbray Mews, London SW6 3NS, United Kingdom